The Goddaughter

JOHANNAH BIRNEY

THE GODDAUGHTER

ISBN-13: 978-0-578-58005-0

DEDICATION

This book is dedicated to men.

THE GODDAUGHTER

JOHANNAH BIRNEY

ACKNOWLEDGEMENTS

I offer my eternal gratitude to the ancestors and the indigenous wisdom keepers who protect the mother. I pray with thanks for Marcela Lobos and the Munay-Ki for the gift of the 13th Rite.

THE GODDAUGHTER

JOHANNAH BIRNEY

(The sound of water falling)

(A voice sings)

Ave Maria

Gratia plena

Dominus tecum

Benedicta tu in mulieribus

Et benedictus fructus

Ventris tui, Jesus

Santa Maria, Santa Maria

Maria, ora pro nobis

Nobis peccatoribus

Nune et in ora

Mortis nostrae

Amen

THE GODDAUGHTER

JOHANNAH BIRNEY

1

I am in a bathtub,

Full of herbs and salts from Peru.

Tomorrow I go on a mission.

Before I go

I must give you these words

...

I spoke to the Godmother.

She told me it was time.

Your initiation is on the

thirteenth of next month.

I will not be there.

So, I am recording this for you now.

When I was your age

I loved sitting in the bath.

Not much has changed.

...

THE GODDAUGHTER

When I was nine, I loved

sitting in the bath.

Once, my eyes were watching a movie

where a black and white world

was turned into color

by Experiencing Humanity.

I saw a woman

find her soul in the warm waters

of the bathtub.

...

Let's begin.

I'm putting a rock in the bathtub now.

It is from the Mapacho River in Peru.

&

It is time to tell you a bath time story.

Not a bedtime story,

a bath time story

JOHANNAH BIRNEY

Once, in the *Land of Flowers,*

during mango season,

I was driving down Pilgrim Road

in a baby blue Cadillac with a woman

named Roxanne.

We were crossing Olive Road in

the rain when I said,

"I'm going to save the world one

orgasm at a time."

I was nine,

and I was declaring my calling.

But you see, that child then

came up with that idea

because in 1999

the movie "*Pleasantville*"

showed a woman having an orgasm

in a bathtub.

3

THE GODDAUGHTER

On some level,

I knew what was happening,

but I thought with my child's mind,

that it came from the water.

Without having to explain myself,

I delivered a prophecy for my life.

And So It Is.

The bath time story of

my lifetime had begun.

2

Seven years later, I was studying with the *Tribe of Benjamin* when it was time to complete the Rite of Confirmation in the Catholic Church.

...

I called out to god and she answered me and told me great and unsearchable things that I did not know. I chose the name Rose. The ceremony was beautiful.

I remember feeling the power of

Saint Rose.

Little did I know how the holy water would flow. Then one day, in a Catholic school library, the nuns instructed a group of young initiates to answer a question using their bodies. They said,

THE GODDAUGHTER

Stand by the fiction

if your answer is NO.

Stand by the biographies

if your answer is YES.

The quest(ion) was this...

"If your friend had an abortion,

would you support her?"

99% of the class stood by the fiction

And they spoke in depth

about why they said NO.

I listened, as I stood by the biographies,

and then it was my turn to speak.

I felt my voice rise from the ground up

And all I did was repeat the question.

JOHANNAH BIRNEY

I said,

"If your friend HAD an abortion...

Would you support her?"

I paused and looked at them

quietly, like we were in a library.

And then in a soft voice I said,

"If grammar serves me, she has

already chosen and gone through the

abortion. So, it is the time after when she

needs support. Would I support her?

OH YES."

...

They stood there, speechless

I turned and walked out of that

library, out of the garden,

and out of the church.

7

THE GODDAUGHTER

3

I refused to continue to answer the
calling I felt to give my life to a church.
So, I found a new library & I started
reading all the books I could get my
hands on about the many ways to pray,
devoting my practice to planting seeds of
a different kind.

...

Then one night after taking a bath,
I went to sleep, and I woke up in a dream.
My grandmother came to me. She
brought me to a house on a hill in a lake
town deep in the woods of New York.
She showed me an ancient chest, opening
it to reveal many books, a bag, and a box.

THE GODDAUGHTER

She opened the books one after the other,
showing me a collection of words written
about our Right to our Rites.

When I woke up, as the morning came
across the horizon, I found my father,
waiting calmly to tell me his mother had
died in the middle of the night.

...

I remember smiling.
So thankful she said goodbye.

I was different after this dream. As we
prepared to return to grandma's home,
I began to write her eulogy for the
funeral, using a page to write
a speech of praise.

JOHANNAH BIRNEY

We returned to the church

by the lake. Gathering grace,

we walked behind her casket

as the sun melted the snow on the

branches, baptizing those who walked

below. The sermon was spoken in a

sacred hall surrounded by stained glass.

As I stepped up to the altar to deliver a

speech of praise for the one they called

Duke, a woman named Mary,

I felt the call.

Her eulogy was supernatural.

They laughed and cried as they listened.

As I spoke freely upon the altar, reading

a speech written by my hand, I

surrendered to the lineage.

And I rose.

THE GODDAUGHTER

4

Nine months after Mary's death, I
crossed the Atlantic by boat to a dock on
the bay. I found myself enrolled in a
five-year initiation in the school they call
the *Four Winds*. For five years I studied,
researched, and experimented with
geniuses and muses, walking in the flesh
through rose gardens.

This chapter of the story is short
because it is a book for another time.
But I can tell you this, I met a guardian
angel while I was there,
someone who loves bath time.
I call them *Spock*.

THE GODDAUGHTER

5

At the very end of our initiation in the
Four Winds, there was one night when
two master consorts came to
initiate me by fire.

They anointed me with the sacrament of
the *jedi* knight. They brought me to the
forest and they unleashed me into the
wild night.

I found a little hill where I could watch
the moon. I sat with the breath of fire
while looking at the eclipsing blood moon
radiating into the night. In a moment of
great ecstasy a miracle happened. First,
a toe came out of the moon, followed by
feet and legs and a body and hair with

15

light-like wings. A being came forth from
the moon and I witnessed in silent awe
for a timeless amount of space.

I was swallowed, surrendered to the bliss
of being in the belly of a whale when I
met *Grandmother Moon.* She looked like
a living woman who had risen from the
center of a white rose. She looked at me
and I looked at her. I answered the
calling beyond confirmation. I
consummated my calling this night
&
I received a humbling commission
from the woman with the moon under her
feet, to travel back to New York City with
my future hoop.
...My mission...

16

JOHANNAH BIRNEY

To converge

the Science of Circles with

the Math of Miracles with

the Art of Orgasms.

THE GODDAUGHTER

6

I went to the airport and I walked out
of a metal bird to the streets of
Brooklyn. It was raining when I got
there. Soon I was flying west
where it wasn't raining. I went back
east and back west, learning the
language between JFK and LAX.

Spock was always close by. We would
gather grace together, showering it in
the city streets, finding where the
sidewalk ends until it was time to go
from the concrete jungle to the plant
kingdom. There is another angel

...

Who I call *OJO* (they had an extra
19

eye the day we met).

A story for another time.

...

Together we three formed a trinity:
Spock, Ojo, and I. We found our way
through the world fully expressing
our art, merging science and math
with laughter and sass.

One day in L.A. on 11/22 we
unleashed a collection of archangel
portals painted to hang on the walls
of the world. We unleashed two
guardian lion spirits from the ancient
temples of Egypt to guard the gift. To
roam the streets of Los Angeles,

to tickle all the angels with their

whiskers, and touch their wings with

their tails.

Once we completed our mission, we

found our way south to the jungles,

to a waterfall that brought us back to

the Four Winds for an upgrade.

THE GODDAUGHTER

7

We landed in a vortex, just west of *the center of the universe*. We met a guardian of *Orion* who then prepared me to meet the mother of the goddess.

We crossed the country one more time before we arrived at her garden's gate. My head was shaved, and I was initiated deeper into the mysteries of the river beneath the river. Many daughters and sisters of the divine arts prepared me to walk where the ground is lava.

It was time for a pilgrimage to the Pacific. They, grandmother of the goddess, sent me to the volcanoes to sit for nine days so that I might

23

THE GODDAUGHTER

gather the grace of

21 WORDS,

as if these

21 WORDS

were the key to the declaration of a young

pilgrim who was living to save the world

one orgasm at a time.

...

It's not time to tell you these words

although I have whispered them into the

wind of your dreams so it is possible

you will remember them

when they leave my lips.

After 13 days of Initiation and a sunrise

transmission from *Haleakala*, I returned

home from the land of lava

to the Land of Flowers with

24

JOHANNAH BIRNEY

...

21 WORDS

...

Then, a second collection was

commissioned to conceive

twelve Archangel Portals to be

painted through my hands.

And so, we began.

144 initiates signed their names in

our guest book that is more like

a quest book

(more like a captain's log in star fleet)

...So to speak...

Gathering in the garden of a gallery,

planted in the city streets

we spoke the 21 WORDS

Over and Over and Over Again

Until the space within and the space

25

beyond the walls were drenched with

truth until we were ready.

Until I was ready.

It was time for an invitation that few

would choose, although it is inevitable.

After initiation into the rose codes, I

learned that Rose is a four-letter word.

I've learned a few other four-letter words.

Like the word WORD

Word Is a four-letter word.

So is the word WOMB.

Sometimes the word womb

can silence a room

Right now, is not the time

to tell you the

21 WORDS.

...

But now you know one,

and I know it is used twice

so, now you know two.

...

WOMB

...

WOMB

...

Hear me out.

Listen closely.

Please.

...

You are entering the world of

sex, drugs, and rock & roll

...

I would like to whisper to you

about the world of

27

THE GODDAUGHTER

womb, ceremony, and the sound of light

...

You are a wise one in a young one's body.

I see you as a future elder when I look at

you. My wish for you as my goddaughter,

My prayer for you as your godmother, is

to tell you the kind of story my

GodMother once told me.

...

A kind of never-ending story,

so to speak.

...

So, let's start again.

Start again.

I learned

21 WORDS

...

I spoke them and shared them

JOHANNAH BIRNEY

With everyone I knew until
I could hold the words
in the palms of my hands
Until my faith needed no proof.

...

Then it was time to test my faith with
temptation. It was time to face the depths
of fear, sadness, pain, and anger with the
devotion held within freedom, peace, joy,
and compassion.

It was time to face my fear so I could
walk through the fire without getting
burned. It was time to return to the altar
to speak and sing, Again and Again.

....

It was time to serve the mother's mother.
It was time to serve the mother.

THE GODDAUGHTER

...

I have heard that people fear public

speaking more than death. So, at a

funeral some would rather die

than give a eulogy.

...

I have put this theory to the test.

8

Within an 11-month window,

My grandmother and my mother died.

...

I was her eldest granddaughter.

I was her only daughter.

...

My mother named me in honor of her

grandmother and the man who loved her.

...

I have spent this lifetime, honoring a

name given to me that beckons me

to *gather grace.*

I am telling you this story, my story,

because on my mother's death bed

she asked me to write this book.

THE GODDAUGHTER

As your godmother, I would like to tell

you the greatest prayer that

I have ever found.

21 WORDS

of simple truth

A prayer that is like a pilgrim, kissing

the soul of humanity's high heart. A

prayer I taught my mother and her

mother. A prayer I taught to your mother.

9

...

It is still not time to say the
21 WORDS

...

After they died, I returned to Atlantis
for one year to honor a year of
mourning, greeting the morning of
each day devoted to feeling and
healing the pain, sadness, fear, and
anger. Asking to be forgiven.

...

I was given time to find oneness with
my father and my brother in the
gardens and the pools of Atlantis.
I found sanctuary within the gates of
the city inside of Lake Worth.

THE GODDAUGHTER

I was given time to rest. Deep rest.

Not depressed. Deep rest.

Then it was time to sit. Not the time

to sleep and so, I received.

10

My first steps were silent and small.

A trinity of warriors escorted me

North to a retreat center in the

woods. For ten days I sat in silence

with a devoted legion of earth angels

walking in the flesh. I enlisted in a

Vipassana course and I listened to a

man speak beyond the grave.

Goenka is his name. His method is

old, older than he. His wisdom is

worth sharing like the rain.

For ten days,

we ate in silence,

we slept in silence,

we washed and walked in silence,

we learned and journeyed in silence.

For ten days I was guided by a trinity

of teachers until it was time to sit in

the cell to answer the call.

Until the bell called time.

And so, I was. As it is.

"That cell though."

11

I found my silence so that

I could find my sound

&

On the 11th day a tribe of initiates went

to a hostel in the forest to dive into a

lake, naked, like masterpieces sculpted to

float. Once we were baptized by fresh

waters we walked through a labyrinth

to find a feast hall where we celebrated

the sound of words with ears attuned to

silence. We could touch and we could

talk! And so, we did until it was decided,

by the desire of many, for words to be

shared. We gathered in the forest under a

moon sky to make an offering to the

mother's mother's mother. We built an

altar to alter our minds. And then they

THE GODDAUGHTER

came; Brother and Sisters

revealed as one.

We gathered our graces until it was time

for me to speak the

21 WORDS

to nurture the night.

When I opened my mouth to speak,

I SANG.

...

I remember once in Los Angeles an old

blues guitarist told me "You can't sing a

song if you don't believe the words, so, if

you want to sing a song forever, make

sure that the words are true for you

eight days a week."

I received

21 WORDS

to liberate the song of my heart and

the sound of my soul. It is a prayer shared that ripples through time by the power of three. A prayer that does not speak of god, unless God is a woman with no name. (giggles)

So, there we were, in the forest, with the men holding the rim & the women holding the center.

I SANG

WE SANG

Each of us uniting our voices together

...

We sang!

We sang for the sisters healing from abortions, the brothers without fathers, women who had been hurt by the hands of men and men who had been hurt by

39

THE GODDAUGHTER

the hands of women.

We sang

21 WORDS

for every

Brother Son Sister Daughter.

We sang for orgasms.

We sang for creation.

We sang for future generations.

We sang our sound and the trees

launched their dance into the wind.

...

We Sang

...

Now is not the time to tell you the

21 WORDS

...

Now is the time to sing to you the

21 WORDS

40

JOHANNAH BIRNEY

That night and this night

I SANG

The womb is not a place

to store fear and pain.

The womb is to create

and give birth to life.

The womb is not a place

to store fear and pain.

The womb is to create

and give birth to life.

The womb is not a place

to store fear and pain.

The womb is to create

and give birth to life.

The womb is not a place

to store fear and pain.

The womb is to create

41

THE GODDAUGHTER

and give birth to life.

Once every brother and sister were
served, we marched to the lake as one,
laughing with hysterical joy and
irreverent euphoria and peace pulsing
from the top of our heads to the tips of
our toes. From the tips of our toes to the
top of our heads. Again, we swam naked
under the moon baptizing the rite in the
waters, offering our rose petals to the
shore so our prayer may be offered for all.

Three petals per person were offered.

...

One prayer per petal

...

A prayer for the planet

JOHANNAH BIRNEY

...

A prayer for our mothers

...

A prayer for our Womb

...

This was an ultimate moment.

While I was swimming, dancing in the
water, I realized I sat in silence for ten
days so I might find the stillness to sing
21 WORDS.
The Rite of the Womb,
the 13th Rite of the Munay-Ki,
a prayer spoken to be sung.
I sat in silence for ten days
to heal the voice of my womb.

THE GODDAUGHTER

12

On this night of song, I received another

mission from an angel called *Anon,*

who told me to prepare to serve a holy

woman who was to give birth to a sage

from the stars. And so, once again, I

traveled south to the Land of Flowers to

find the woman they call Maria Virginia.

I found her & I came to her home to

honor the lives that were to be born.

The sisterhood was served and the

brotherhood held the rim once again as

we prayed for a mother and child to be

born; born to a tribe of warriors who

planned to be on this planet so that the

crystal children could rise.

The circle of life and death and life

THE GODDAUGHTER

whirled through the room as we spoke

and sang the words of the Rite of the

Womb, anchoring

21 WORDS.

We anointed Maria with song, we blessed

her body as the throne, we filled a

bathtub with water and roses, &

we celebrated with the Queen of Angels.

A few days later a child was born.

A few weeks later, it was my mother's

birthday; a birthday of a different sort.

Halloween.

For the first time, I met my mother's true

form. I found myself blessed by the holy

day of Halloween. Surrounded by

a harem of heroines, I celebrated my

mother's birthday with tricks and treats.

On this night, I received a mission that I was to follow in eleven days. So, once again, I went to prepare for 11/11.

THE GODDAUGHTER

13

I went to the land where the streets smell
of roses. I took a dirt road to a Shinto
gate, marking the end of the mundane
and the entrance of the wetlands. Many
hands worked as one (too many to count)
to prepare a portal for a sacred fire whose
smoke would rise to the Stars.

On this holy land where the birds have
made their home, I found the sanctuary
necessary to conceive twin sculptures in
honor of the one they call *Sophia.* On the
banks of a river, using a sacred hoop, I
sculpted two mandalas with holy centers
that a dragon could fly through.

...

Then on 11/11 when the November sky

49

THE GODDAUGHTER

was setting soft light, we gathered the

sisterhood and brotherhood

to once again share

21 WORDS

as one, Spreading the Rite of The Womb

in a ceremony so sacred it must not be

shared. But I can tell you this.

This day I speak of ...

This year I speak of ...

was the 100-year anniversary of the last

day of WWI

11/11/18

the 100-year anniversary of the first day

The World declared Peace.

Since then humanity has been on a

planetary journey, uniting heroes,

heroines, and unicorns as a holy trinity

to answer the call. The call to pray as
One World.

So, on this holiest of historic days we
gathered, circling around a sacred fire in
the center of a crystal matrix sealed into
stone until the work was done.

...

Praying together, rising as one, we
walked to the riverbank and offered our
roses to the waters that flow in the Land
of the Flowers. On 11/11/18 once again
as the sun set, I prepared to fly south
with the migrating birds. Back to Basel.

To the heart of Miami.

With dragons.

14

On my way, I went to Pineapple Park in
West Palm Beach to sit on the deck of a
Queen's Court on the front lines with a
wise woman, a wild warrior woman.
I call her Athena. Her name is Athena,
her legal name is Athena. And yes,
her Harvard degree is there for you to
see, for those who need 3D proof. She has
nothing to prove because her faith is
strong and her specialty is schooling the
youth. She is ancient. She is softer than
rose water and her truth is sharper than
a thorn and her roots are healing beyond
words.

...

She prepared me for a secret battle
that I am not yet ready to tell you.

THE GODDAUGHTER

...

Athena was the doula who delivered me

into the hands of the ones I call

The Sisters.

15

When the twin dragons were activated for
duty

we took the road to Basel

to climax

every day

of Miami Art Week.

I danced in the streets

satisfied by graffiti

and I stood in the galleries

giggling beside

sculptures of circles

that summon

the Dragon tribes.

At the pinnacle,

the climax,

the height of success

All I wanted to do was heal, rest, and undress.

...

And then I realized that I was your godmother. When your mother came to my side, together with the sons and daughters of dragons, we descended into the street of society to sing our song. We delivered 24 dozen roses to the masses with smiles in our hearts and secrets in our eyes, like jedis in disguise.

The Sisters are the ones who made ME into a WE, the ones who saw through my eyes so I could become a WE. The Sisters are the secret, the secret to success, the secret to the final test of this text. The sisters are two:

One older, one younger

JOHANNAH BIRNEY

One taller, one smaller

One for the left hand, One for the right.

They are a double-edged sword. They are

Excalibur. We are three. We are three

women making magic and calling it Art.

We are three women giving birth to life

And calling it Culture.

We three, we climax every day.

Every Day.

And when the work was done,

It was done. It was done. It was done.

It was time to face the holiday season.

...

Christmas was hard.

...

And so was the New Year that followed.

...

Valentine's day was harder.

The year before, Valentine's day 2018,

was the day my mother told me she had

cancer.

Again.

...

It was Holy Ash Wednesday, the first day

of Lent in the Catholic faith. She asked

me to go to church with her. When the

ashes lined my third eye, she told me the

news.

...

One year later to the day on 2/14/2019,

I found an anger, a darkness, a rage

I remember my soul was begging to

release. In a moment of deep grief, I

found an incredible strength

I opened a door with such force

I ripped it from its hinges,

off the wall, off the frame.

My adrenaline evaporated with time.

I lost my mind when I realized I hurt my

hand. I hurt the hand that had painted,

the hand that held a hoop, the hand that

fed my body, the hand that held the pen.

It was then that I knew it was time to ask

for help and I opened a door into a

new world and bought this voice recorder.

....

I found a young master, a merge between

Yoda and Archangel Michael, in the body

of a good man. In confidential

conversations he asked me questions that

reprogrammed my programs,

59

reconnecting the dots...

For months I worked to heal my hand in the cave of my heart. Countless medicine women and countless medicine men laid their hands on me until I was ready to put myself back together again.

16

Then there was a day that changed my
world forever, a day that took every day
before to prepare. You see, for a while
now, your mom and I have been sitting
in the ceremony of circle, gathering and
sharing our gifts and wisdom.

On International Women's Day 2019,
we gathered thirteen women in a mango
tree garden around a simple fire.
We called on the directions, the Angels,
the Ancestors, and the Ascended Masters.
We stood shoulder to shoulder as a
unified sisterhood dancing with
irreverent sacred joy.

Across the world, my father was with the

brotherhood, serving the ones I call the

boat people.

...

Suddenly, my body was electrified

from the ground up until my soul was far

above and beyond me.

...

Suddenly, my soul returned to my body

as if I had jumped through space and

time, as if I my spirit had teleported.

...

The next morning, I spoke to my father,

the one they call Bones. He told me a

story about the night before. He said that

he found a woman lifeless at a table and

he took her into his arms to bring her

back. He tried and it did not work. Then

he tried again. This time, his prayer was
answered and her throat was cleared. He
saved her life that night. Bones is the
King of Atlantis by night and by day he is
Maître D, the one they call to make a
reservation. He works at a restaurant
that has existed for 108 years. Floating
above the Lake Worth Lagoon, my father
serves the members of Palm Beach with
the dignity of 10,008 war horses, running
bareback, declaring peace while feasting
in the field of plenty. This man, my
father, saved a woman's life, a woman
who was choking to death above the Lake
Worth Lagoon the very moment I was
teleporting on
INTERNATIONAL WOMEN'S DAY.
From this moment forward

THE GODDAUGHTER
I was never the same.

17

Then, the eleventh day of the fourth
month came to pass on my path. My first
birthday without my mother on earth. My
first birthday with the Earth as my
mother.

...

My birthday was one day shy
of nine months from
my mother's final breath.

...

I have learned that if you throw
the word birth into the word death
you get the word

Breath.

On the anniversary of my first breath,
the daughters of the goddess, my sisters
and friends, came to Atlantis, with roses

in their hands. Thirteen gathered as
Athena gave me a bluebird that she found
dead in the street, while walking a dog in
Palm Beach. On this day, using a great
sword and pink salt, I received my wings
with a humbled heart and an exalted
spirit. I was reborn. Reborn, like a
phoenix from the ashes of my mother.

...

A smarter woman than I once asked me
"Do you know what spirituality is?
Spirituality is asking god for a blue
feather...
then holding out your hand with absolute
faith that one will fall into your palm
from a window in the sky."
On my birthday the Goddess of Wisdom
gave me a pair of wings & taught me the

power of Spirit. The power of spirituality.

Now it is time to tell you about a letter.

This bath is done.

It is done

It is done

It is done

...

0

I'm out of the bathtub and I am on the
balcony listening to the wind in the night
sky praying for the Truth. NOW

Mother's Day was ten months to the day
after my mother's death.

5/12/19

I sat the way I learned at the lotus pond
and I spoke to a tree in the atrium that
was seeded in her honor.

...

While the sun was setting, Poseidon
charioted me from Atlantis to Palm
Beach, where I crossed the bridge over
the Lake Worth Lagoon. While passing
the sea wall of *mar a lago,* I held a rock

from the rivers of Peru, then I dropped it

in the water. (giggle)

As a gift to the mother. (giggle)

You see, everyone called my grandmother

Mar *The Sea.*

She loved to stand high on a hill,

watching the sun set behind a horizon of

trees on the other side of the lake.

She was famous, infamous

even, for saying, *"The lake looks good."*

...

So, on Mother's Day I dropped a rock, a

river rock I named Rocky, gathered by

the hands of Athena on a holy pilgrimage

through the mountains of Peru. On this

day, Mother's Day I held Rocky in

my hands and I spoke with prayer and

70

song for nine hours. I told the rock much

more than I am telling you now and

Rocky recorded my share, mastering the

art of remembering. When I gave Rocky

to the waters besides Palm Beach

...

I asked Rocky to tell the water of the

Lake Worth Lagoon a story I call

the river beneath the river

....

You see, everyone in my mother's family

called her Rocky. My father called her

Roxy. I called her Roxanne because that

was her name. Her name means

dawn of the day.

...

So, on Mother's Day I took a rock and I

dropped it, while riding on Poseidon's

back as a prayer. A gift.

My grandmother's funeral was at St.

Mary's. My mother's funeral was at St.

Anne's. I learned how to speak free when

I delivered their eulogies. Then, I learned

the name of another mother, the name of

the mother of the one they call 45, the

one who lives in the winter white

house on the shores of the Lake Worth

Lagoon. His mother's name was

Mary Anne

She died in the year 2000. She was born

in Scotland where my father's Mother

Mary was born. (Pause)

To the mother of the one they call 45...

To the womb that gave birth to

the one they call 45...

To the womb that gave birth to

the mother of 45...

To all the mothers who mothered the

Lineage of the one they call 45...

I call on you now...

Hear my prayer.

THE WOMB IS NOT A PLACE

TO STORE FEAR OR PAIN

THE WOMB IS TO CREATE AND

GIVE BIRTH TO LIFE

THE WOMB IS NOT A PLACE

TO STORE FEAR OR PAIN

THE WOMB IS TO CREATE AND

GIVE BIRTH TO LIFE

THE WOMB IS NOT A PLACE

TO STORE FEAR OR PAIN

THE WOMB IS TO CREATE AND

GIVE BIRTH TO LIFE

THE WOMB IS NOT A PLACE

TO STORE FEAR OR PAIN

THE WOMB IS TO CREATE AND

GIVE BIRTH TO LIFE

(Pause)

I'm not done. We have just begun.

I spent Mother's Day praying with

the dead mothers of humanity

until I made peace with

the secret that took her to the grave.

...

I forgave with surrender born in water. I

remembered with wisdom born from rock.

(Pause)

JOHANNAH BIRNEY

It wasn't the brain cancer or the lung
cancer or the heart disease or the
Hodgkin's disease. It wasn't the 36 years
of fighting sickness that killed my
mother. It was a secret that she swept
under the rug. You see, on her deathbed,
after years of praying
21 WORDS,
she found the courage to say one word
that cured her soul's suffering.

A few years earlier, she told me that
she had been raped by a man.

...

We worked to heal her womb with
21 WORDS

Together we prayed in the ceremony of

circle. Together we prepared

for her final prayer.

Her last Rites

Her Final Words

We were talking about forgiveness before

her family came to say goodbye. I knelt

beside her and asked, "Mom, do you

forgive the man who raped you?"

She looked at me with eyes I had never

seen. She took a deep breath and said,

"MEN"

Not man. She said

"MEN"

She drew a map of America with her
finger and named all the places she had
been raped. The trail of tears she could
never speak; until the end of her road,
before she dropped her robes, when
she met a rose blessed by the river
goddess, Ganga Devi. On this day Ganga
gave my mother a rose so powerful that it
turned my mother *scared* so that she
might speak of *sacred* forgiveness.

...

You see she had been raped many times.
It took her decades to speak of one time.

In her final time she spoke of the many,
the Many Men.

And so, as it is

THE GODDAUGHTER

...

My sweet goddaughter, when my mother
made me promise to her on her deathbed
that I would write a book about roses,
rising to speak and sing, I knew this story
would not end with crime.
It ends in the center, in the center where
I have had time to connect the dots.

...

You see, it's not the death of a mother or
the birth of a sun. It's not the rape of a
sister or the abortion of an untethered
soul.
The womb is not
a place to store fear and pain.
The womb is
to create and give birth
to life.

...

After she told me her secret, after she
asked me to write this book, I prayed and
found many teachers who would help me
turn lifetimes into a few pages that can
fit in your back pocket.

...

My mother would always say,
"Hands are for healing, not for hurting."

...

As my hand holds this voice recorder, I
am healing my heart. I realize I hurt my
hand because this story called to be
spoken and transcribed. It was to be
written once it was spoken.

...

I pray to flip the script and bring this full
circle until it becomes a spiral anchoring
heaven and earth together "Forever and a

Day", as Duke would say.

"Save the world one orgasm at a time"

It must be said again.

...

I was twenty-five when someone looked

at me at the dawn of a sunrise and said,

"Where are you from?" And I looked at
them, I giggled, and I said

"An orgasm."

They laughed until they looked like a

Hafiz poem talking to a *Rumi* poem,

embodying great lions pissing on sacred

ground. "Save the world one orgasm at a

time." I am and so are you. Someone

smarter than me once said, "You are the

moment you decide to be." Goddaughter,

Your life is the fruit of a moment

branching out through time built by the

hands of your family connecting bodies.

...You are an Orgasm....

You are a living, breathing, divine

Moment, before and after and while you

have sex. If it is the first time or the last

time, I pray

(Pause)

(Laugh)

That first it is an answer to

a prayer. I pray

you are safe.

You feel free.

You feel joy.

I pray

A smarter woman than I once said,

"There is only one woman and one man

on this planet with a billion faces."

I hope that as you move forward

you choose your beloveds with prayer.

I trust there are many handfuls to receive

from the BILLIONS before you.

Partners who will pray with you

because you are the cathedral.

..

This brings me to my final twist.

It is time to stretch.

82

JOHANNAH BIRNEY

Much like Atlantis
is a city within Lake Worth,
Within Palm Beach County,
Within Florida,
Within the USA.

This year, Mother's Day (5/12)
was a holiday within the 40 days of
Easter, within the Spring, within the
year before 2020.

...

It is time to connect some more dots.
To do so, we must speak about a church
that is calling my name.

....

I call on the priesthood of the Catholic
Church as the granddaughter of the man

they call Fran. As the granddaughter

of Francis, I call the upon the clergy to

hear our prayer.

THE WOMB IS NOT A PLACE TO
STORE FEAR OR PAIN

THE WOMB IS TO CREATE AND GIVE
BIRTH TO LIFE

THE WOMB IS NOT A PLACE TO
STORE FEAR OR PAIN

THE WOMB IS TO CREATE AND GIVE
BIRTH TO LIFE

THE WOMB IS NOT A PLACE TO
STORE FEAR OR PAIN

THE WOMB IS TO CREATE AND GIVE
BIRTH TO LIFE

JOHANNAH BIRNEY

THE WOMB IS NOT A PLACE TO STORE FEAR OR PAIN

THE WOMB IS TO CREATE AND GIVE BIRTH TO LIFE

It is Rhetorical Question Time

Do you remember 4/15, as Holy Week

started off with a big bang, when *Notre*

Dame gave the heavens a fireworks

display on Tax Day?

Remember 4/19? *Good Friday* was on

Bicycle Day, making an LSD EGO death

joke beyond the grave the same day

Christ traveled on an eclipse to the other

side.

Remember 4/20? The holy day of

cannabis! Did you know medicine men

85

call weed *Santa Maria* because they

believe it is the living embodiment of

the holy virgin Mother Mary?

Interesting.

Did you know 4/20, is also the birthday of

St. Rose, the patron saint of the

indigenous, a patron of Peru,

a woman beyond borders.

4/21?

Easter Sunday.

The first Sunday after the full moon

following the *Equinox.*

A good day to pray.

4/22?

Easter Monday was also *Earth Day.*

Can you believe it?

Gaia's glorious day of celebration!

(giggle)

86

I laugh because I can hear the end and I
laugh because I can feel you laughing.
Goddaughter, you are a 16-year-old
woman in a world turning 2020.
The funny bone about holidays,
especially ones celebrating resurrection,
is that the signs are loud when your
questions are open and clear.

So here I am, this is the final moment.
Do you remember,
I said I'd tell you about a letter?
(long pause)

...

"HELP ME!"
Those are the last words my mother
spoke to me but not the last words she
wrote to me when she was dying. I found

the funniest cards that I could find and gave them to her blank. She wrote to my father and my brother and her father and her brother and sisters and friends.

She saved mine for last.

When she came to my card, she looked at me softly. She said, "I'm gonna take a nap, I'll write your card when I wake up".

But she never had the strength to hold a pen again.

...

The cover of my card said, "You make 29 look fabulous every time." It is blank still.

...

I delivered her letters after her death and

I saw her words live beyond her body.
I saw a quantum story unfold and I loved
my blank card. Then, then one day I
found one of Roxanne's journals with a
page addressed to my name. Today is
exactly one year from the day that she
wrote this letter to me.

...

I Am Going To Read It Now

Dear Johannah Katherine Rose,
I love you! Remember the *Superman*
Movie? He's a fetus growing and traveling
in space, getting downloaded. We have
done that with you. You've got the
download. You know you are a daughter
of the Lord. Nothing else matters.
"Jesus lives in our hearts."

THE GODDAUGHTER

Age three

You are an integral part of the kingdom
of god, writing reading speaking with
fluid grace, a prayer warrior in your own
right. Believe it, receive it, speak it.
Open your wings and fly! Go, Johannah.

Vision of bathtub revealed
May 24, 2018

One year to the day since this letter was
written, I am speaking this story for you,
for the world to read and to plant a seed.
You see, lovers are like pilgrims who have
come to the gates of your womb.

I pray your pilgrim's hands are
washed with clean water.

I pray they are wise in ways to

make you wet as rain.

...

MORE SO

I pray that if anyone ever touches you

in any way that makes you feel

your voice has not been heard,

I pray that you tell me.

Tell Someone.

Your Story Matters!

You are a woman.

Your choice is sacred.

Your body is your temple.

Your sex is holy mass.

Your name is your denomination.

THE GODDAUGHTER

Hear me now loud and clear

....

As you sit in your first circle on

the thirteenth of this month.

As you sit in your first ceremony,

I pray you leave behind the ordinary and

you enter into the extraordinary.

As It Is.

This is my living will and testament

on this voice recorder.

In this living will, you are the beneficiary

of two chests built from the trunks of

ancient trees. An inventory log of your

inheritance is attached to a copy of this

manuscript before the glossary.

...

JOHANNAH BIRNEY

To be your godmother means I would care
for you if anything ever kept your mother
from caring for you. Don't ever fear your
mother's death for she will live so very
long for she knows how to pray.
Trust me, that woman
Knows How To Pray.

The key to receiving this living will in full
is hidden in a collection of 18 books that I
have read, written by authors who live to
write so that we may taste many flavors
of the truth with our eyes.

I ask that you take these books and you
Read until you finish every book. The key
to your inheritance is written by your
word by my word

AS IT IS

Goddaughter,

I give this inheritance to you

NOW

Before you sit in ceremony on the 13th I

will come to you with roses and one chest.

...

This inheritance is a treasure chest

The books are the compass.

You are the map.

We must not wait.

Your inheritance calls your name.

I am going to live a very long time

and so are you

...Eternally...

Until all are free

94

...

This leads me to tell you

a little death joke.

...

You see, on Easter Morning, as the

naughty reformed Catholic that I

am, who has since sought truth from the

13 corners of the circle, I celebrated Holy

Sunday before I got out of bed with a

little death in honor of the French.

This is a translation test.

You see

I dance in circles and I paint in circles I

stand shoulder to shoulder in circle I sit

with the living and the dying in life's

circle. But there is one circle that is your

ally to end all wars; held not in the palm

of your hand, but in the tips of your

fingers. You see, the secret to life is in the

womb, yes, but first it is found touching

the temple door and on Easter Sunday

before rising from my sheets, after

waking from a dream-filled sleep, I

circled a way I have circled before

using my middle finger to tickle

tiny circles casting a rhythm

like a drum for a temple dancer

around and around and around.

Goddaughter,

if you find the power of your orgasm

before you find a partner, you will know

the divinity of your breath and the sacred

spiral of your spine and it will be easier

to make choices that align with the

divine. So, I will tell you how I found

mine. One orgasm at a time. Learning

how to masturbate with your hands is the

most renewable resource Gaia has given

women to win the peace of the womb.

It is a gift from god to the goddess

to own the privilege of being a

woman, simply by opening our thighs.

It is a secret gift of sorts with Great

Power and Great Responsibility.

I have devoted my life to the rose and

the womb and the healing of the planet.

...This is the secret to my devotion...

When I prepare to give myself the grace

of an orgasm, I say prayers in my mind

That I know by heart.

...

I start with one line that does it for me

every time.

I say these four words

"I love you, Jesus."

Why?

Someone smarter than I am once said,

"When you tell Jesus *I love you*,

He tells you *I love you*

1008 times back."

Wrapped in the lotus of this love

I declare

God Thinks My Sexuality Is Glorious

&

I pray

"I love you, Jesus."

...

JOHANNAH BIRNEY

Then I pray a few more.

I pray the Rite of Womb and I nurture

Freedom, Joy, Peace and Compassion

Before I have come to the end

I pray a trinity prayer from the

mountains of Tibet because

the Dali Lama said, "Western women are

going to save the world." I dedicate the

merit of good karma so that all may

benefit from the prayer of my orgasm.

...

I say,

"By this merit may all attain

omniscience. May it defeat the enemy of

wrongdoing from the stormy waves of

birth, old age, sickness, and death.

From the ocean of *samsara* may I free all
beings."

(recite once)

Emulating the hero Manjushri,
Samantabhadra and all those with
knowledge,

I too make a perfect dedication of all
actions that are positive.

(recite three times)

May Bodhicitta, precious and sublime

Arise where it has not yet come to be

And where it has arisen may it never fail

But grow and flourish ever more and
more

(recite three times)

When it is done.

It is done

It is done

It is done

And I rise to greet the day I did not cast

the first stone on Mother's Day.

I am not without sin, but

I did sing, I did pray my way.

When I was done

I dropped Rocky in the water the way

Stephen Colbert drops the mic every

night he lights up the stage.

So, here is my offering, I want you to

understand why I laugh. To speak this

story I read a chest of books and I wrote a

chest of books. Goddaughter, If you read

these books by your 18th birthday,

I will give you $10,008

This is not a bible.

This is a bibliography.

But I am your godmother and You are my
Goddaughter and I want to put my money
where my mouth is because I believe you
are destined for unsearchable heights.

I have lived a life of initiation for 29
years. I have lived to see all my mothers
pass on. But your mother she lives on
and I, I live on. The Sisterhood is
4 Billion Strong.

We must not wait for death to inherit
the treasures of truth that grow from
the trees that map the return to Eden.

As It Is

We must not wait a moment more. We
must rush, slowly. Here is the mission

...

Now that I have spoken these words

into this voice recorder, they will be

transcribed, printed, and bound with a

spine. How? Hear me out

...

It only takes the square root of 1%

to turn a light source into a laser.

That's science. Imagine humanity as a

light bulb and peace as a laser.

What's the population?

That's math.

Imagine what would happen if

pussy prayed for the planet.

That's the art of orgasm

Then think about where we live.

I live in Atlantis inside of Lake Worth,

next to the lagoon and the one they call

45. Think about when we are.

Next year is 2020

...

Next year is the election

And I have a vision.

I see the square root of 1% of the

population of the USA praying together

at 11:11 AM and PM

Night and Day

until victory is declared with

peace, ease, and grace.

I see this story will be read by many.

First you and me. Then...

It will be read by 17 women and 17 men

34 humans together on the shore

Representing the square root of 1% of the

population of Palm Beach County.

Then the square root of 1% of Florida

458 copies.

Then it will be read by a tribe of 1889

the square root of 1% of

the population of the USA.

And then it will spread

to 8944, the square root of 1% of the

globe, so that all of humanity may

benefit, spreading until the world unites

to pray for the healing of the maker of the

one who is melting in the

winter White House.

Waiting for his retirement to come.

Come again? Is this a joke?

You see Jesus' mama's name was Mary.

THE GODDAUGHTER

Mary's mother's name was Anna.

...

I delivered my grandmother Mary's eulogy. I delivered Mar's eulogy at Saint Mary's. I delivered Roxanne's eulogy at Saint Anne's. So, this, this speech, this voice recorder, this transcription, this gift for you.

This is a your "dead mama" joke, not because it is funny. It's a "your mama" joke because 45 is my neighbor and I forgive him because he knows not what he has done and he doesn't know what he doesn't know. This is a joke because they ask me,

"What's so funny?"

And the answer is Forgiveness.

Then they ask, "Are you joking?"

It sounds something like this

"Your mama's so dead…"

Telling jokes is not my job, so Stephen, if

you don't mind stepping in here, this

one's for you to sink your teeth into

until you are twirling in circles singing

the Sound of Music.

Because there is a 46th.

Colbert, shall we collaborate?

How about Noah?

Can you build me an ark for my angels?

The winter White House is melting

like the wicked witch of the west.

The Land of Flowers is flooding.

…

I have a vision of

107

a legion of 11,111 willing

to pray the Rite of the Womb in

dedication to healing

the womb that made a man who is

soon to be forgotten. A man who is

begging to be forgiven for he knows not

what he has done.

To the son of Mary Anne, I say to you,

You are my neighbor. You are forgiven

Because god is a woman. Now go be a

good boy and say 13 Hail Marys

and when you are done, we will talk

about your daddy. I will not pass

judgment on you, but the court will.

So, learn how to sit in a cell

the way the Buddhas do.

It is done

JOHANNAH BIRNEY

It is done

It is done

I declare to save the world

one orgasm at a time

until every living

man, woman, & unicorn

--animal and plant--

above and below and within

is free to live and create life.

...

Goddaughter, I love you. Today you

receive the first chest. When you have

read the contents of the first, You will

inherit the contents of the second.

...

Someone much smarter than me once

said, "The secret to life is to inhale with

109

gratitude and exhale with love."

I say the secret to having an orgasm

is to pray with your breath, while

you pray with your mind, while

you pray with your heart,

while you pray with your womb,

while you pray with your body!

Goddaughter, you are an orgasm,

saving the world every time you are kind.

Humankind.

9780062507563
9780997935509
9781781809082
9780943358505
9781573241762
9780345409874
9781438936734
9780446567190
9780394404288
9780140195811
9780375760396
9780060637248
9780060256678
9781844095698
9780763619619
9780876120798
9780517543054

A book
A lighter
A flashlight
An orange box
A voice recorder
A red and white shall
A jar of tri-colored roses
A container of Holy Water
A bag of Peruvian bath salt
A council of thirteen crystals

Inventory Chest 2

9781577315933
13 Large Moleskine journals
13 Small Moleskine journals
1 Chopstick covered in paint
1 Brown Book
1 Blue Book
1 Green Book
1 Messenger bag
1 Navy Uniform
1 Ceremony Robe
1 Snake fossil
1 Kalachakra tapestry
1 Metal lockbox
1 Large ritual spoon
1 Golden crystal

P.S.

Until Victory is won, I cast this covenant.

More than 6,000 languages are spoken in the 239 countries of the world.

I swear to study these native tongues and travel to these motherlands so that I may share the wisdom that has liberated me from fear, sadness, pain, and anger.

I swear to serve the world with this knowledge.

I swear to save the world one orgasm at a time.

About the Author

Johannah Birney is a woman on a mission to save the world one orgasm at a time.

She is an independent researcher who has spent the past decade studying the intersection between environmental sustainability, sex alchemy, and ancient womb wisdom.

As an experienced keynote speaker and storyteller, Johannah is deeply influenced by the work of Joseph Campbell and the role of mythology in cultural evolution.

A maverick in the art world, Johannah has exhibited her paintings in LA, NYC, and Miami Art Basel.

Specializing in circle technology, her life's work revolves around revealing esoteric wisdom en masse.

Johannah travels far and wide to educate women and men in womb healing rituals for intergenerational restoration.

Find her portfolio at www.johannah.art

CPSIA information can be obtained
at www.ICGtesting.com
Printed in the USA
LVHW091427100120
643245LV00001B/163/P